Auguste Rodin

Auguste Rodin

Rainer Maria Rilke

translated by
Jessie Lemont and Hans Trausil

introduced by
Alexandra Parigoris

The J. Paul Getty Museum, Los Angeles

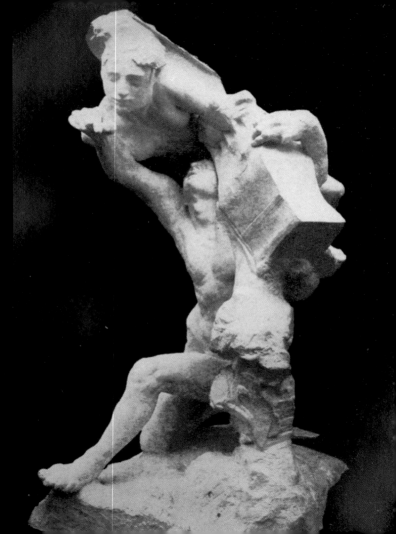

INTRODUCTION

ALEXANDRA PARIGORIS

We might be excused for not remembering the American writer Jessie Lemont, who, with the assistance of her German-born husband, Hans Trausil, provided the first translation into English of Rainer Maria Rilke's 1903 book on Rodin. It fell out of print for fifty years, but this was the edition that introduced a whole generation of artists and thinkers to this famous encounter between young poet and famous artist. The sculptor William Tucker was one of many it inspired, recalling how 'it was a well-worn copy [presumably of this text] that found its way into my hands as a student in the late fifties, and fired an enthusiasm for the art of sculpture (if not at that time for the art of Rodin) that I later discovered was the common experience of many artists on their first encounter with this inspiring text.'

If Tucker also admitted, 'lyric poetry in a language we do not speak can never speak to us', we might add sadly that lyric poetry today in any language is one that is lost to all but the lucky few. This republication of Rilke's

Opposite: Orphée (Orpheus), 1892

Rodin is an opportunity to revisit the world of some of the actors who spoke it with some degree of fluency.

This account will begin with Jessie Lemont, the young American who travelled to Paris in 1908, like so many other writers and artists of her generation, to meet Auguste Rodin, the artist and sculptor then at the height of his fame. The visit was not entirely disinterested as she planned to give a series of lectures on Rodin in America upon her return, which she did in 1909 and 1910. It was during this first stay that she met Rilke through Rodin later that summer.

At the time, Rilke was without doubt the more established writer, and he greatly impressed Lemont, who would later recall her meeting with the poet as 'one of the most vital experiences of her life'. For Rilke, the encounter with Lemont, who had come to Rodin as a writer, was a salutary change from the crowds of admirers that thronged the sculptor's villa at Meudon. Rilke, in turn, was sufficiently impressed and interested in Lemont to order a copy of his *Rodin* specially for her, which he sent on 30 September 1908 with an accompanying note written in French, expressing 'the liveliest good wishes for her lectures,' adding, 'I am sure that you will prepare victories for the genius of Rodin in your country, whose long future you will courageously reinforce by conveying such a message to it.' Although we might suspect Rilke's

motives, we should not denigrate the nature of such exchanges which at the time provided invaluable means for the transmission and circulation of ideas between people of different backgrounds who shared the same cultural interests and for whom Rodin's work represented the pinnacle of a life devoted to art. Lemont might be described as a passionate Germanophile, translating nineteenth-century Lieder into English and producing in 1921 what was then considered the definitive biography of Beethoven. But it was her interests in *fin-de-siècle* British æstheticism that scholars believe brought her close to Rilke, who, in spite of a poor grasp of English, was deeply conversant with the ideas of Walter Pater and Oscar Wilde which he had read in translation. This is further evidenced by Lemont's gift to Rilke at Christmas 1908 of a copy of *Studies in Seven Arts* written by Arthur Symons, a disciple of Pater's. However, it would be Symons rather than Rilke whom Lemont would quote in her article, 'Auguste Rodin: A visit to Meudon', which appeared in *The Craftsman* in June 1911, and which she forwarded to Rilke. In his letter thanking her, the poet admits that he read 'the beautiful pages you devote to Rodin, as far as my poor grasp of English would permit.' No doubt Lemont's German was also not up to reading Rilke at first, but, by the outbreak of the First World War, she published in New York an important selection

of Rilke's poems, with the help of her husband, which would long remain the best introduction to Rilke's poetry in America. When their translation of the *Rodin* appeared in 1920 following the sculptor's death in 1919, they could claim to be as conversant with the poet's sensibility as with the art of the sculptor they all admired.

Before turning Rilke's text, we need to remind ourselves of the context within which it emerged. It may come as a surprise to those acquainted with the stormy relationship that Rilke would entertain with the sculptor that the *Rodin* was written as a work to order at a time when Rilke's circumstances were particularly precarious and was published in 1903, long before he would accept a post as Rodin's secretary, taking up residence at the villa in Meudon, and even longer before the later 1907 lecture, which accompanied subsequent editions of the book as a second section. Thus it was the commission in the spring of 1902 from his acquaintance Professor Richard Muther to write a volume dedicated to Rodin's work for a new German series of art monographs that was eagerly taken up by the poet in urgent need of income. It must have helped also that his wife, Clara Westhoff, was acquainted with the sculptor after studying at the short-lived Institut Rodin in Paris in 1899. Rilke used the occasion of his letter of introduction to the sculptor to forward his wife's regards and photos of her recent

work. The same letter reveals how little Rilke actually knew about Rodin, since he quite openly asks the sculptor about publications already dealing with his art or biography. This did not deter Rodin, who responded warmly to the poet who was planning to come to Paris 'to steep myself in your creations and specially to penetrate into the spirit of your drawings, of which so little is yet known abroad.' The commission also provided Rilke with the means to effectuate the much-discussed separation from Clara, so that they could both lead the 'existence of undisturbed solitude needed to accomplish their long and serious life's work.' Had it not been for this separation, we would not have had the brilliant correspondence that Rilke maintained with Clara throughout his Parisian stay, which provides us with some of his best writing about art, ranging from his first impressions of Paris, 'that strange, strange city of sickness and death', to the deeply insightful passages on the paintings of Cézanne.

The encounter with Rodin provided Rilke with a living example of an artist who embraced his task as work and for whom working at his art was life-affirming: 'travailler, c'est vivre sans mourir pour les artistes'[1]. This more than anything confronted the poet with the question of

(1) 'For artists, to work is to live immortally'

his own perspective on art: could one work at writing? And what became of 'inspiration' which had been essential to the make-up of the melancholic *fin-de-siècle* artist steeped in morbidity? The answer is given in the opening epigraph, taken from Pomponius Gauricus: 'Writers work through words – Sculptors through matter'. Finding the words and the language that would bridge the divide, to articulate the work of the sculptor, was the task of Rilke's *Rodin*.

The text combines Rodin's thoughts about art, gathered during their meetings at Meudon, and passages of lyrical descriptions that convey the effect the work had on the poet. Unlike the conversations reported in his letters to Clara, in the book, Rodin is given no voice: he is simply the object of Rilke's analysis. The tone is intentionally impersonal, lest too intimate a portrait distract the reader from taking the proper measure of the achievement of this extraordinary figure: 'the work that has grown far beyond this name's sounds and limitations'. We are struck by the persistent use Rilke makes of the term 'work', no doubt an acknowledgement to Rodin's despair at the loss of prestige of the craftsman. Work reaffirms the task of the sculptor as one of making, crafting work out of matter with his hands.

Reversing the terms of the *paragone* (the comparison between the arts), Rilke, quoting Rodin, admired the

sculpture of the cathedrals which had rescued mankind from uncertainty by giving them a refuge in reality: 'the real and simple'. Thus sculpture was 'better than paint; for painting was a delusion, a beautiful and skilful deception'. Rilke adds poetically that sculpture 'is more than word and painting, more than picture and symbol, because it is the materialisation of mankind's hopes and fears', and not the representation of any lofty ideals, 'the great idea'. This materialisation is made manifest in Rodin's surfaces and thus Rilke sees in this fundamental element the subject of his art. It is the surfaces which are the result of the sculptor's modelling, and thus intimately linked to his touch, and the translation of viewing.

Much is made of hands, whether they be active and standing in metonymically for the sculptor as 'the two hands out of which the world has risen' or expressively modelled works, vividly acting out some existential drama: 'hands whose five bristling fingers seem to bark like the five jaws of a dog of Hell.' What matters is that all these hands 'without belonging to a body are alive.'

Rodin's subjects confirm that he has reinstated the language of the body, but the body freed from the strata of costumes and history, and brought back to its essence in gesture. Rilke goes through all those poses and brings out the gesture through evocative description: 'the pain of awakening' in the *Man of Primal Times* (*L'Âge*

d'Airain, ill. p. 42) whose arms are 'still so heavy that the hand of one rests upon the top of the head', or the figure of *Eve* (ill. p. 45) 'with head sunk deeply into the shadow of the arms […] she bends forward as though listening over her own body.' These are more than descriptions: the poet gives us the enactment of an embodied experience within these works that he transubstantiates through language, and thus brings these representations of life to life.

Rodin's figures gesture without arms; touching is equated to looking like the pathos 'of the Duse in a drama of d'Annunzio's when she is painfully abandoned and tries to embrace without arms and to hold without hands.' Similarly, Rilke writes to Clara after his first visits to the pavilion in Meudon filled with the many dazzling plaster-casts: 'my eyes hurt me, so do my hands'.

'One stands before them as before something whole': Rilke's text is not memorable only for its profound appreciation of the partial figure, denouncing the viewers' prejudice and confirming that a body does not have to be complete or to have arms to be a body. It also recognises Rodin's unique way of re-assembling figures from the vast array of parts that he had at his disposal, not only creating gesturing figures out of diverse parts, but discovering new, powerfully eloquent gestures. To Rilke, juggling similes, Rodin's bodies 'listen like faces' and

'lift themselves like arms.' Language translates what the sculptor transmutes.

What the *Rodin* text still conveys today is the powerful impact that language can have on the experience of viewing this body of work. It is the way Rilke brings together unexpected combinations of metaphors in his descriptions, the way the text constantly makes demands on the reader, mediating between viewing and reading, that still holds her attention. This is no longer *fin-de-siècle* æstheticism. Rilke's Rodin is far from the 'holy hush of ancient sacrifice', and has emerged as the modern Romantic in the twentieth-century sense because he has restored the whole concept of work to sculpture, and thus encouraged Rilke to understand writing in this way. To Rilke, Rodin was the artist who made as well as the artist who contemplated, and like his *Thinker* was 'the man who realizes the greatness and terror of the spectacle about him, because he thinks it.'

Writers work through words –
Sculptors through matter
POMPONIUS GAURICUS
in his essay
De Sculptura (c. 1504)

The hero is he who is immovably centred
EMERSON

Rodin was solitary before fame came to him and afterward he became, perhaps, still more solitary. For fame is ultimately but the summary of all misunderstandings that crystallize about a new name.

Rodin's message and its significance are little understood by the many men who gathered about him. It would be a long and weary task to enlighten them; nor is this necessary, for they assembled about the name, not about the work, – a work that has grown far beyond this name's sound and limitations, and that has become nameless as a plain is nameless or a sea that has a name but on the map, in books, and to men, but which is, in reality, but distance, movement and depth.

The work that is to be spoken of in these pages developed through long years. It has grown like a forest and has not lost one hour. One walks among these thousand forms overwhelmed with the imagination and the craftsmanship which they represent, and involuntarily one looks for the two hands out of which this world has risen. One thinks of how small man's hands are, how soon they tire, and how little time is given them to move. And one longs to see these hands that have lived like a hundred hands; like a nation of hands that rose before sunrise for the accomplishment

of this work. One asks for the man who directs these hands. Who is this man?

He is a man rich in years: and his life is one that cannot be related. It began and still continues; stretches out deeply into a great age, and to us, it seems as though it had passed many hundreds of years ago. It perhaps had a childhood; a childhood in poverty – dark, groping and uncertain. And maybe it possesses this childhood still, for, says St Augustine somewhere, whither should it have gone? It holds, perchance, all its past hours, the hours of expectation and abandonment, the hours of doubt and the long hours of need. It is a life that has lost nothing and has forgotten nothing; a life that has absorbed all things as it passed, for only out of such a life as this, we believe, could have risen such fullness and abundance of work; only such a life as this, in which everything is simultaneous and awake, in which nothing passes unnoticed, could remain young and strong and rise again and again to high creations. Perchance the time will come when someone will picture this life, its details, its episodes and its conflicts. Someone will tell a story of a child that often forgot to eat because it seemed more important to him to carve inferior wood with a cheap

Opposite: L'homme qui marche (The Walking Man), 1900-1907

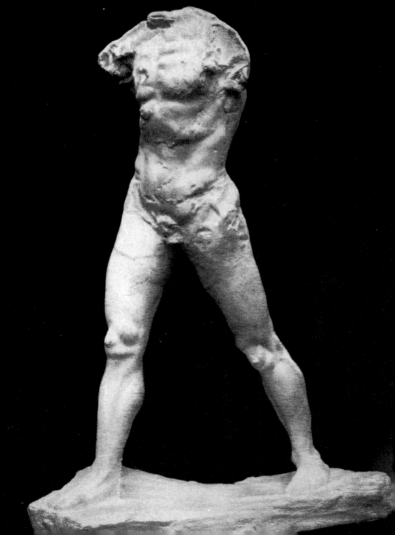

knife, and someone will relate some event of the days of early manhood that contained promise of future greatness – one of those incidents that are intimate and prophetic.

Perhaps some such thought as that which, five hundred years ago, a monk expressed to young Michel Colombe, may have suggested itself to Rodin on one of the crossways, at the beginning of his work: 'Travaille, petit, regarde tout ton saoul et le clocher à jour de Saint Pol, et les belles œuvres des compaignons, regarde, aime le bon Dieu, et tu auras la grâce des grandes choses.' 'And thou wilt have the grace of the great things.' For it was just that which Rodin was seeking: the grace of the great things.

The galleries of the Louvre revealed to the young artist radiant visions of the antique world; visions of southern skies, and of the sea, and far beyond rose heavy stone monuments, reaching over from immemorial civilizations into times not yet existent. There were stones that lay as if asleep but that held a suggestion that they would awake on some last judgment day, stones on which there was nothing mortal. There were others that bore a movement, a gesture that had remained as fresh as though it had been caught there in order to be given to some child that was passing by.

Not alone in the great works and in these monuments was this vitality alive: the unnoticed, the small, the concealed, were not less filled with this deep inward excitement, with this rich and surprising unrest of living things. Even stillness, where there was stillness, consisted of hundreds and hundreds of moments of motion that kept their equilibrium.

There were small figures, animals particularly, that moved, stretched or curled; and although a bird perched quietly, it contained the element of flight. A sky grew behind it and hung about it; the far distance was folded down on each of its feathers, and should these feathers spread out like wings, the wide expanse of them would be quite great. There was stillness in the stunted animals that stood to support the cornices of the cathedrals or cowered and cringed beneath the consoles, too inert to bear the weight; and there were dogs and squirrels, woodpeckers and lizards, tortoises, rats and snakes. At least one of each kind; these creatures seemed to have been caught in the open, in the forest and on roads, and the compulsion to live under stone tendrils, flowers and leaves must have changed them slowly into what they were now and were to remain forever. But other animals could be found that were born in this petrified environment, without remembrance of a former existence. They

were entirely the natives of this erect, rising, steeply ascending world. Over skeleton-like arches they stood in their fanatic meagreness, with mouths open, like those of pigeons; shrieking, for the nearness of the bells had destroyed their hearing. They did not bear their weight where they stood, but stretched themselves and thus helped the stones to rise. The bird-like ones were perched high up on the balustrades, as though they were on the way to other climes, and wanted but to rest a few centuries and look down upon the growing city. Others in the forms of dogs were suspended horizontally from the eaves, high up in the air, ready to throw the rainwater out of their jaws that were swollen from vomiting. All had transformed and accommodated themselves to this environment; they had lost nothing of life. On the contrary, they lived more strongly and more vehemently – lived forever the fervent and impetuous life of the time that had created them.

And whosoever saw these figures felt that they were not born out of a whim nor out of a playful attempt to find forms unheard of before. Necessity had created them. Out of the fear of invisible doomsdays of a hard faith men had freed themselves by these visible things; from uncertainty men had taken refuge in this reality. They sought God no more by inventing

images of Him or by trying to conceive the Much-too-far-One; but they evinced their piety by carrying all fear and poverty, all anxiety and all pleading of the lowly into His house. This was better than to paint; for painting was a delusion, a beautiful and skilful deception. Men were longing for the more real and simple. Thus originated the strange sculpture of the cathedrals, this cross-breed of the heavy-laden and of the animals.

As the young artist looked from the plastic art of the Middle Ages, back to the Antique, and again beyond the Antique into the beginnings of untold pasts, did it not seem as though the human soul had longed again and again through the bright and dark periods of history, for this art which expressed more than word and painting, more than picture and symbol; this art which is the humble materialization of mankind's hopes and fears?

At the end of the Renaissance there was the flowering of a great plastic art; at that time when life renewed itself, when there was a revealment of the secret of faces, and a great vital movement was in the state of growth.

And now? Had not a time come again that was urging toward this expression – this strong and impressive exposition of what was unexpressed, confused,

unrevealed? The arts somehow had renewed themselves, zeal and expectation filled and animated them. But perhaps this art, the plastic art that still hesitated in the fear of a great past, was to be called upon to find that which the others sought gropingly and longingly. This art was to help a time whose misfortune was that all its conflicts lay in the invisible.

The language of this art was the body. And this body – when had one last seen it?

Strata after strata of costumes were piled over it like an ever-renewed varnish; but under this protecting crust the growing soul had changed it; and this growing soul worked breathlessly at remodelling the expression of the faces. The body had become a different one. Were it now unveiled, it would perhaps reveal the imprint of a thousand new impressions as well as the stamp of those old mysteries that, rising from the unconscious, reared their dripping heads like strange river-gods out of the singing blood. And this body could not be less beautiful than that of the Antique. It must be of a still higher beauty. For two thousand years life had held this body in its hands and had moulded it, had forged it, now listening, now hammering, night and day. The art of painting dreamed of this body, adorned it with light and illumined it with twilight, surrounded it with all softness and all

delight; touched it like a petal, and in turn was swept by it as by a wave. But plastic art, to which it in truth belonged, as yet of this body knew nothing.

Here was a task as great as the world. And he who stood before it and beheld it was unknown and struggling under the necessity of earning his bread. He was quite alone and if he had been a real dreamer, he would have dreamed a beautiful and deep dream – a dream that no one would have understood – one of those long, long dreams in which a life could pass like a day. But this young man who worked in the factory at Sèvres was a dreamer whose dream rose in his hands and he began immediately its realization. He sensed where he had to begin. A quietude which was in him showed him the wise road. Here already Rodin's deep harmony with Nature revealed itself; that harmony which the poet Georges Rodenbach calls an elemental power. And, indeed, it is an underlying patience in Rodin which renders him so great, a silent, superior forbearance resembling the wonderful patience and kindness of Nature that begins creation with a trifle in order to proceed silently and steadily toward abundant consummation. Rodin did not presume to create the tree in its full growth. He began with the seed beneath the earth, as it were. And this seed grew downward, sunk deep its roots and

anchored them before it began to shoot upward in the form of a young sprout. This required time, time that lengthened into years. 'One must not hurry,' said Rodin to the few friends who gathered about him, in answer to their urgence.

At that time the war came and Rodin went to Brussels. He modelled some figures for private houses and several of the groups on the top of the Bourse, and also the four large corner figures on the monument erected to Loos, the city's mayor, in the Parc d'Anvers. These were orders which he carried out conscientiously, without allowing his growing personality to speak. His real development took place outside of all this; it was compressed into the free hours of the evening and unfolded itself in the solitary stillness of the nights; and he had to bear this division of his energy for years. He possessed the quiet perseverance of men who are necessary, the strength of those for whom a great work is waiting.

While he was working on the Exchange of Brussels, he may have felt that there were no more buildings which admitted of the worth of sculpture as the cathedrals had done, those great magnets of plastic art of past times. Sculpture was a separate thing, as was the easel picture, but it did not require a wall like the picture. It did not even need a roof.

It was an object that could exist for itself alone, and it was well to give it entirely the character of a complete thing about which one could walk, and which one could look at from all sides. And yet it had to distinguish itself somehow from other things, the ordinary things which everyone could touch. It had to become unimpeachable, sacrosanct, separated from chance and time through which it rose isolated and miraculous, like the face of a seer. It had to be given its own certain place, in which no arbitrariness had placed it, and it must be intercalated in the silent continuance of space and its great laws. It had to be fitted into the space that surrounded it, as into a niche; its certainty, steadiness and loftiness did not spring from its significance but from its harmonious adjustment to its environment.

Rodin knew that, first of all, sculpture depended upon an infallible knowledge of the human body. Slowly, searchingly, he had approached the surface of this body from which now a hand stretched out toward him, and the form, the gesture of this hand, contained the semblance of the force within the body. The farther he progressed on this remote road, the more chance remained behind, and one law led him on to another. And ultimately it was this surface toward which his search was directed. It consisted of

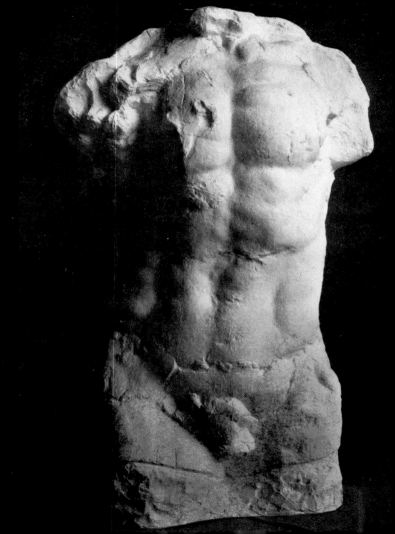

infinitely many movements. The play of light upon these surfaces made manifest that each of these movements was different and each significant. At this point they seemed to flow into one another; at that, to greet each other hesitatingly; at a third, to pass by each other without recognition, like strangers. There were undulations without end. There was no point at which there was not life and movement.

Rodin had now discovered the fundamental element of his art; as it were, the germ of his world. It was the surface, – this differently great surface, variedly accentuated, accurately measured, out of which everything must rise, – which was from this moment the subject-matter of his art, the thing for which he laboured, for which he suffered and for which he was awake.

His art was not built upon a great idea, but upon a minute, conscientious realization, upon the attainable, upon a craft.

There was no haughtiness in him. He pledged himself to a humble and difficult beauty that he could oversee, summon and direct. The other beauty, the great beauty, had to come when everything was prepared, as animals come to a drinking-place in the forest in the late night when nothing foreign is there.

Opposite: Grand Torse (Large Torso), c. 1890

With this awakening Rodin's most individual work began. Not until now had all the traditional conceptions of plastic art become worthless to him. Pose, grouping, composition now meant nothing to him. He saw only innumerable living surfaces, only life. The means of expression which he had formed for himself were directed to and brought forward this aliveness.

The next task was to become master of himself and of his abundance. Rodin seized upon the life that was everywhere about him. He grasped it in its smallest details; he observed it and it followed him; he awaited it at the crossroads where it lingered; he overtook it as it ran before him, and he found it in all places equally great, equally powerful and overwhelming. There was not one part of the human body that was insignificant or unimportant: it was alive. The life that was expressed in faces was easily readable. Life manifested in bodies was more dispersed, greater, more mysterious and everlasting. Here it did not disguise itself; it carried itself carelessly where there was carelessness and proudly with the proud. Receding from the stage of the face it had taken off its mask and concealed itself behind the scenes of garments. Here in the body Rodin found the world of his time as he had recognised the world of the Middle Ages in

the cathedrals. A universe gathered about this veiled mystery – a world held together by an organism was adapted to this organism and made subject to it. Man had become church and there were thousands and thousands of churches, none similar to the other and each one alive. But the problem was to show that they were all of One God.

For years Rodin walked the roads of life searchingly and humbly as one who felt himself a beginner. No one knew of his struggles; he had no confidants and few friends. Behind the work that provided him with necessities his growing work hid itself awaiting its time. He read a great deal. At this time he might have been seen in the streets of Brussels always with a book in his hand, but perhaps this book was but a pretext for the absorption in himself, in the gigantic task that lay before him. As with all creative people the feeling of having a great work before him was an incitement, something that augmented and concentrated his forces. And if doubts or uncertainties assailed him, or he was possessed of the great impatience of those who rise, or the fear of an early death, or the threat of daily want, all these influences found in him a quiet, erect resistance, a defiance, a strength, and confidence – all the not-yet-unfurled flags of a great victory.

Perhaps it was the past that in such moments came to his side, speaking in the voice of the cathedrals that he went to hear again and again. In books, too, he found many thoughts that gave him encouragement. He read for the first time Dante's *Divina Commedia*. It was a revelation. The suffering bodies of another generation passed before him. He gazed into a century the garments of which had been torn off; he saw the great and never-to-be-forgotten judgment of a poet on his age. There were pictures that justified him in his ideas; when he read about the weeping feet of Nicholas the Third, he realized that there *were* such feet, that there was a weeping which was everywhere, over the whole of mankind, and there were tears that came from all pores.

From Dante he came to Baudelaire. Here was no judgment, no poet, who, guided by the hand of a shadow, climbed to the heavens. A man who suffered had raised his voice, had lifted it high above the heads of others as though to save them from perishing. In this poet's verses there were passages, standing out prominently, that did not seem to have been written but moulded; words and groups of words that had melted under the glowing touch of the poet; lines that were like reliefs and sonnets that carried like columns

Opposite: The Kiss (Paolo et Francesca), 1886

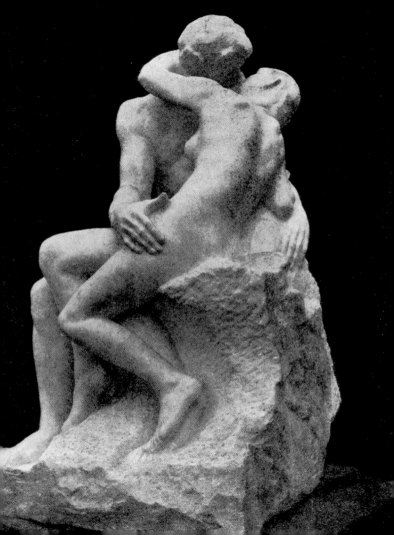

with interlaced capitals the burden of a cumulating thought. He felt dimly that this poetic art, where it ended abruptly, bordered on the beginning of another art, and that it reached out toward this other art. In Baudelaire he felt the artist who had preceded him, who had not allowed himself to be deluded by faces but who sought bodies in which life was greater, more cruel and more restless.

After having read the works of these two poets they remained always near him; his thoughts went from them and yet returned to them again. At the time when his art took form and prepared itself for expression, when life as it presented itself before him had little significance, Rodin dwelt in the books of the poets and gleaned from the past. Later, when as a creator he again touched those realms, their forms rose like memories in his own life, aching and real, and entered into his work as though into a home.

At last, after years of solitary labour, he made the attempt at a step forward with one of his creations. It was a question put before the public. The public answered negatively. And Rodin retired once more for thirteen years. These were the years during which he, still unknown, matured to a master and became the absolute ruler of his own medium, ever working, ever thinking, ever experimenting, uninfluenced by

the age that did not participate in him. Perhaps the fact that his entire development had taken place in this undisturbed tranquillity gave him later, when men disputed over the value of his work, that powerful certainty. At the moment when they began to doubt him, he doubted himself no longer, all uncertainty lay behind him. His fate depended no more upon the acclamation or the criticism of the people; it was decided at the time they thought to crush it with mockery and hostility. During the period of his growth no strange voice sounded, no praise bewildered, no blame disturbed him.

As Parsifal grew so his art grew in purity, alone with itself and with a great eternal Nature. Only his work spoke to him. It spoke to him in the morning when he awakened, and in the evening it sounded in his hands like an instrument that has been laid away. Hence his work was so invincible. For it came to the world ripe; it did not appear as something unfinished that begged for justification. It came as a reality that had wrought itself into existence, a reality which *is*, which one must acknowledge.

Like a monarch who, hearing that a city is to be built in his kingdom, meditates whether it would be well to grant the privilege, and hesitates; and finally goes forth to see the place and finds there a

great powerful city which is finished, which stands as though from eternity with walls, towers and gates, so the world came when ultimately called to the completed work of Rodin.

This period of Rodin's maturity is limited by two works. At its beginning stands the head of *The Man with the Broken Nose*, at its end the figure of *The Man of the Primal Age*. *L'Homme au nez cassé* was refused by the Salon in the year 1864. One comprehends this rejection, for one feels that in this work Rodin's art was mature, certain and perfected. With the inconsiderateness of a great confession it contradicted the requirements of academic beauty which were still the dominating standard.

In vain Rude had given his *Goddess of Rebellion* on the top of the triumphal gate of the Place de l'Étoile that wild gesture and that far-reaching cry. In vain Barye had created his supple animals; and *The Dance* by Carpeaux was merely an object of mockery until finally it became so accustomed a sight that it was passed by unnoticed.

The plastic art that was pursued was still that based upon models, poses and allegories; it held to the superficial, cheap and comfortable *métier* that was satisfied with the more or less skilful repetition of some

Opposite: L'Homme au nez cassé (The Man with the Broken Nose), 1864

sanctified appeal. In this environment the head of *The Man with the Broken Nose* should have aroused the storm that did not break out until the occasion of the exhibition of some later works of Rodin. But probably it was returned almost unexamined as the work of someone unknown.

Rodin's motive in modelling this head, the head of an ageing, ugly man, whose broken nose even helped to emphasize the tortured expression of the face, must have been the fullness of life that was cumulated in these features. There were no symmetrical planes in this face at all, nothing repeated itself, no spot remained empty, dumb or indifferent. This face had not been touched by life, it had been permeated through and through with it as though an inexorable hand had thrust it into fate and held it there as in the whirlpool of a washing, gnawing torrent.

When one holds and turns this mask in the hand, one is surprised at the continuous change of profiles, none of which is incidental, imagined or indefinite. There is on this head no line, no exaggeration, no contour that Rodin has not seen and willed. One feels that some of these wrinkles came early, others later, that between this and that deep furrow lie years, terrible years. One knows that some of the marks on this face were engraved slowly, hesitatingly, that others

were traced gently and afterwards drawn in strongly by some habit or thought that came again and again; one recognizes sharp lines that must have been cut in one night, as though picked by a bird in the worn forehead of a sleepless man.

All these impressions are encompassed in the hard and intense life that rises out of this one face. As one lays down this mask one seems to stand on the height of a tower and to look down upon the erring roads over which many nations have wandered. And as one lifts it up again it becomes a thing that one must call beautiful for the sake of its perfection. But this beauty is not the result of the incomparable technique alone. It rises from the feeling of balance and equilibrium in all these moving surfaces, from the knowledge that all these moments of emotion originate and come to an end in the thing itself. If one is gripped by the many-voiced tortures of this face, immediately afterwards there comes the feeling that no accusation proceeds from it. It does not plead to the world; it seems to carry justice within itself, to hold the reconciliation of all its contradictions and to possess a forbearance great enough for all its burden.

When Rodin created this mask he had before him a man who sat quiet with a calm face. But the face was that of a living person and when he searched

through it he saw that it was as full of motion, as full of unrest, as the dashing of waves. In the course of the lines there was movement; there was movement in the contours of the surfaces; shadows stirred as in sleep and light seemed to softly touch the forehead. Nothing possessed rest, not even death; for decay, too, meant movement, dead matter still subject to life. Nature is all motion and an art that wished to give a faithful and conscientious interpretation of life could not make rest, that did not exist, its ideal. In reality the Antique did not hold such an ideal. One has only to think of the *Nike*. This piece of sculpture has not only brought down to us the movement of a beautiful maiden who goes to meet her lover, but it is at the same time an eternal picture of Hellenic wind in all its sweep and splendour. There was no quiet even in the stones of still-older civilizations. The hieratically retained gesture of very ancient cults contained an unrest of living surfaces like water within a vessel. There were currents in the taciturn gods that were sitting; and those that were standing commanded with a gesture that sprang like a fountain out from the stone and fell back again causing many ripples.

This was not movement that opposed the intrinsic character of the sculpture. Only the movement that does not complete itself within the thing, that is not

kept in balance by other movements, is that which extends beyond the boundaries of sculpture. The plastic work of art resembles those cities of olden times where the life was spent entirely within the walls. The inhabitants did not cease to breathe, their life ran on; but nothing urged them beyond the limits of the walls that surrounded them, nothing pointed beyond the gates and no expectation opened a vista to the outer world. However great the movement of a sculpture may be, though it spring out of infinite distances, even from the depths of the sky, it must return to itself, the great circle must complete itself, the circle of solitude that encloses a work of art. This was the law which, unwritten, lived in the sculptures of times gone by. Rodin recognized it; he knew that that which gave distinction to a plastic work of art was its complete self-absorption. It must not demand nor expect aught from outside, it should refer to nothing that lay beyond it, see nothing that was not within itself; its environment must lie within its own boundaries. The sculptor Leonardo has given to Mona Lisa that unapproachableness, that movement that turns inward, that look which one cannot catch or meet. Probably his Francesco Sforza contained the same element; it carried a gesture which was like a proud envoy of state who returned after a completed mission.

During the long years that passed between the mask of *The Man with the Broken Nose* and the figure of *The Man of Primal Times* many silent developments took place in Rodin. New relations connected him more closely with the past of the art of sculpture, and the greatness of this past, which has been a restriction to so many, to him had become the wing that carried him. For if he received during that time an encouragement and confirmation of that which he wished and sought, it came to him from the art of the antique world and from the dim mystery of the cathedrals. Men did not speak to him. Stones spoke. *The Man with the Broken Nose* had revealed how Rodin sought his way through a face. *The Man of Primal Times* proved his unlimited supremacy over the body. 'Souverain tailleur d'ymaiges' – this title, which the masters of the Middle Ages bestowed on one another without envy and with serious valuation, should belong to him.

Here was a life-sized figure in all parts of which life was equally powerful and seemed to have been elevated everywhere to the same height of expression. That which was expressed in the face, that pain of a heavy awakening, and at the same time the longing for that awakening, was written on the smallest part of this body. Every part was a mouth that spoke a language

Opposite: L'Âge d'Airain (The Man of Primal Times), 1876

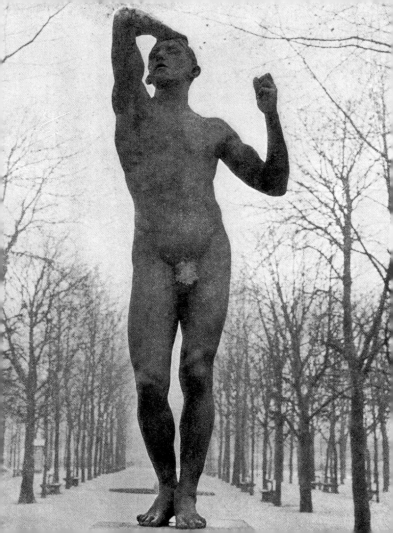

of its own. The most critical eye could not discover a spot on this figure that was the less alive, less definite and clear. It was as though strength rose into the veins of this man from the depths of the earth. This figure was like a silhouette of a tree that has the storms of March still before it and trembles because the fruit and fullness of its summer lives no more in its roots, but is slowly rising to the trunk about which the great winds will tear.

The figure is significant in still another sense. It indicates in the work of Rodin the birth of gesture. That gesture which grew and developed to such greatness and power here bursts forth like a spring that softly ripples over this body. It awakens in the darkness of primal times and in its growth seems to flow through the breadth of this work as though reaching out from bygone centuries to those that are to come. Hesitatingly it unfolds itself in the lifted arms. These arms are still so heavy that the hand of one rests upon the top of the head. But this hand is roused from its sleep, it concentrates itself quite high on the top of the brain where it lies solitary. It prepares for the work of centuries, a work that has no measure and no end. And the right foot stands expectant with a first step.

One would say of this gesture that it is wrapped into a hard bud. In a thought's glow and a storm in

will it unfolds itself and that *St John* steps forth with excited, speaking arms and with the splendid step of one who feels Another follow him. The body of this man is not untested. Deserts have glowed through it, hunger has made it ache and all thirsts have tried it. He has endured and has become hard. His lean, ascetic body is like a forked piece of wood that encloses, as it were, the wide angle of his stride. He walks... He walks as though all distances of the world were within him and he distributed them through his mighty step. He strides... His arms speak of this step, his fingers spread and seem to make the sign of striding in the air.

This *St John* is the first that walks in the work of Rodin. Many follow. The citizens of Calais begin their heavy walk, and all walking seems to prepare for the mighty, challenging step of Balzac.

The gesture of the standing figure develops further. It withdraws into itself, it shrivels like burning paper, it becomes stronger, more concentrated, more animated. That *Eve*, that was originally to be placed over the *Gates of Hell*, stands with head sunk deeply into the shadow of the arms that draw together over the breast like those of a freezing woman. The back is rounded, the nape of the neck almost horizontal. She bends forward as though listening over her own body

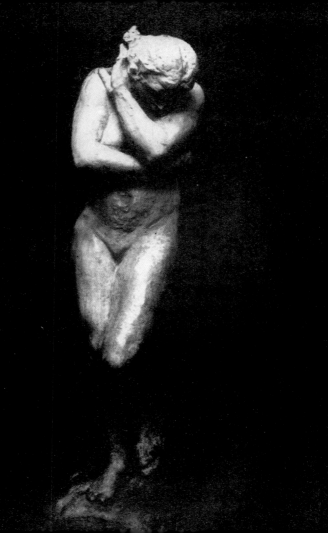

in which a new future begins to stir. And it is as though the gravity of this future weighed upon the senses of the woman and drew her down from the freedom of life into the deep, humble service of motherhood.

Again and again in his figures Rodin returned to this bending inward, to this intense listening to one's own depth. This is seen in the wonderful figure called *La Méditation* and in that immemorable *Voix Intérieure*, the most silent voice of Victor Hugo's songs, that stands on the monument of the poet almost hidden under the voice of wrath. Never was human body assembled to such an extent about its inner self, so bent by its own soul and yet upheld by the elastic strength of its blood. The neck, bent sidewise on the lowered body, rises and stretches and holds the listening head over the distant roar of life; this is so impressively and strongly conceived that one does not remember a more gripping gesture or one of deeper meaning. It is striking that the arms are lacking. Rodin must have considered these arms as too facile a solution of his task, as something that did not belong to that body which desired to be enwrapped within itself without the aid of aught external. When one looks upon this figure one thinks of Duse in a drama of d'Annunzio's, when she is painfully abandoned and tries to embrace

Opposite: Ève (Eve), c. 1881

without arms and to hold without hands. This scene, in which her body has learned a caressing that reaches beyond it, belongs to the unforgettable moments in her acting. It conveys the impression that the arms are something superfluous, an adornment, a thing of the rich, something immoderate that one can throw off in order to become quite poor. She appeared in this moment as though she had forfeited something unimportant, rather like someone who gives away his cup in order to drink out of the brook.

The same completeness is conveyed in all the armless statues of Rodin: nothing necessary is lacking. One stands before them as before something whole. The feeling of incompleteness does not rise from the mere aspect of a thing, but from the assumption of a narrow-minded pedantry, which says that arms are a necessary part of the body and that a body without arms cannot be perfect. It was not long since that rebellion arose against the cutting off of trees from the edge of pictures by the Impressionists. Custom rapidly accepted this impression. With regard to the painter, at least, came the understanding and the belief that an artistic whole need not necessarily coincide with the complete thing, that new values, proportions and balances may originate within the pictures. In the art of sculpture, also, it is left to the artist to make out of

many things one thing, and from the smallest part of a thing an entirety.

There are among the works of Rodin hands, single, small hands which, without belonging to a body, are alive. Hands that rise, irritated and in wrath; hands whose five bristling fingers seem to bark like the five jaws of a dog of Hell. Hands that walk, sleeping hands, and hands that are awakening; criminal hands, tainted with hereditary disease; and hands that are tired and will do no more, and have lain down in some corner like sick animals that know no one can help them. But hands are a complicated organism, a delta into which many divergent streams of life rush together in order to pour themselves into the great storm of action. There is a history of hands; they have their own culture, their particular beauty; one concedes to them the right of their own development, their own needs, feelings, caprices and tendernesses. Rodin, knowing through the education which he has given himself that the entire body consists of scenes of life, of a life that may become in every detail individual and great, has the power to give to any part of this vibrating surface the independence of a whole. As the human body is to Rodin an entirety only as long as a common action stirs all its parts and forces, so on the other hand portions of different bodies that cling

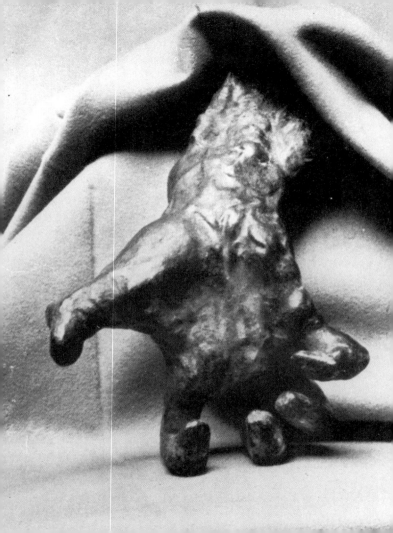

to one another from an inner necessity merge into one organism. A hand laid on another's shoulder or thigh does not any more belong to the body from which it came, – from this body and from the object which it touches or seizes something new originates, a new thing that has no name and belongs to no one.

This comprehension is the foundation of the grouping of figures by Rodin; from it springs that coherence of the figures, that concentration of the forms, that quality of clinging together. He does not proceed to work from figures that embrace one another. He has no models which he arranges and places together; he starts with the points of the strongest contact as being the culminating points of the work. There where something new arises, he begins and devotes all the capacity of his chisel to the mysterious phenomenon that accompanies the growth of a new thing. He works, as it were, by the light of the flame that flashes out from these points of contact, and sees only those parts of the body that are thus illuminated.

The spell of the great group of the girl and the man that is named *The Kiss* lies in this understanding distribution of life. In this group waves flow through the bodies, a shuddering ripple, a thrill of strength,

Opposite: Étude de main (Study of a Hand), c. 1885

49

and a presaging of beauty. This is the reason why one beholds everywhere on these bodies the ecstasy of this kiss. It is like a sun that rises and floods all with its light.

Still more marvellous is that other kiss *L'éternelle Idole*. The material texture of this creation encloses a living impulse as a wall encloses a garden. One of the copies of this marble is in the possession of Eugène Carrière, and in the silent twilight of his house this stone pulsates like a spring in which there is an eternal motion, a rising and falling, a mysterious stir of an elemental force. A girl kneels, her beautiful body is softly bent backward, her right arm is stretched behind her. Her hand has gropingly found her foot. In these three lines which shut her in from the outer world her life lies enclosed with its secret. The stone beneath her lifts her up as she kneels there. And suddenly, in the attitude into which the young girl has fallen from idleness, or reverie, or solitude, one recognizes an ancient, sacred symbol, a posture like that into which the goddess of distant, cruel cults had sunk. The head of this woman bends somewhat forward; with an expression of indulgence, majesty and forbearance, she looks down as from the height of a still night upon the man who sinks his face into her bosom as though into many blossoms. He, too, kneels, but deeper, deep

in the stone. His hands lie behind him like worthless and empty things. The right hand is open; one sees into it. From this group radiates a mysterious greatness. One does not dare to give it one meaning; it has thousands. Thoughts glide over it like shadows, new meanings arise like riddles and unfold into clear significance. Something of the mood of a Purgatorio lives within this work. A heaven is near that has not yet been reached, a hell is near that has not yet been forgotten. Here, too, all splendour flashes from the contact of the two bodies and from the contact of the woman with herself.

Another conception of the theme of the contact of living surfaces and moving planes is that stupendous *Porte de L'Enfer* on which Rodin has worked for twenty years and the final casting into bronze of which is imminent. Advancing simultaneously in the pursuit of the import of the movements of planes and their points of confluence, Rodin came to seek bodies that touched one another on many points, bodies whose movements were more vehement, stronger and more impetuous. The more mutual points of contact two bodies offered, the more impatiently they rushed upon each other like chemicals of close affinity. The tighter the new whole which they formed held together, the more they became like one organism.

From *The Gates of Hell* memories of Dante emerged. Ugolino; the wandering ones, Dante and Virgil, close together; the throng of the voluptuous from among whom like a dried-up tree rose the grasping gesture of the avaricious. The centaurs, the giants and monsters, the syrens, fauns and wives of fauns, all the wild and ravenous god-animals of the pre-Christian forest rose before him. He conjured all the forms of Dante's dream as though from out the stirring depths of personal remembrance and gave them one after another the silent deliverance of material existence. Hundreds of figures and groups were thus created. The visions of the poet who belonged to another age awakened the artist who made them rise again to the knowledge of a thousand other gestures; gestures of seizing, losing, suffering and abandoning, and his tireless hands stretched out farther and farther beyond the world of the Florentine to ever-new forms and revelations.

This earnest, self-centred worker who had never sought for material and who desired no other fulfilment than was attainable by the increasingly maturing mastery of his chisel thus penetrated through all the dramas of life. The depths of the nights of love unfolded themselves to him and revealed the dark, sorrowful and blissful breadth of a realm like that of a still-heroic world in which there were no garments,

in which faces were extinguished and bodies were supreme. With senses at white heat he sought life in the great chaos of this wrestling, and what he saw was Life.

Life did not close in about him in sultry narrowness: the atmosphere of the alcoves was far away. Here life became work; a thousandfold life throbbed in every moment. Here was loss and gain, madness and fright, longing and sorrow. Here was a desire that was immeasurable, a thirst so great that all the waters of the world dried up in it like a single drop. Here was no lying and denying, and here the joys of giving and taking were genuine and great. Here were the vices and blasphemies, the damnations and the beatitudes; and suddenly it became evident that a world was poor that concealed or buried all this life or pretended that it did not exist. *It was!*

Alongside of the whole history of mankind was this other history that did not know disguises, conventions, differences or ranks, that only knew strife. This history, too, had its evolution. From an instinct it had become a longing, from a physical possessorship between man and woman it had become an uplifting desire of human being for human being. Thus this history appears in the work of Rodin; still the eternal struggle of the sexes, but the woman is no more

the overpowered or willing animal. She is longing and awake like the man, and both man and woman seem to have met in order to find their souls. The man who rises at night and softly seeks another is like a treasure-seeker who wishes to find on the crossroads of sex the great happiness. To discover in all lusts and crimes, in all trials and all despair, an infinite reason for existence is a part of that great longing that creates poets. Here humanity hungers for something beyond itself. Here hands stretch out for eternity. Here eyes open, see Death and do not fear him. Here a hopeless heroism reveals itself whose glory dawns and vanishes like a smile, blossoms and withers like a rose. Here are all the storms of desire and the calms of expectation. Here are dreams that become deeds and deeds that fade into dreams. Here, as at a gigantic gambling table, great fortunes are lost or won.

Rodin's work embodied all this. He who had seen so much life found here life's fullness and abundance: the body each part of which was will, the mouths that had the form of cries which seemed to rise from the depths of the earth. He found the gestures of the ancient gods, the beauty and suppleness of animals, the reeling of old dances, the movements of forgotten divine services, strangely combined with new gestures that had originated during the long period in which art

was alien and blind to all these relations. These new gestures were particularly interesting to him. They were impatient. As someone who seeks for an object for a long time becomes more and more helpless, confused, and hasty, and finally creates a disorder in an accumulation of things about him, so the gestures of mankind who cannot find reason for existence have become more and more impatient, nervous and hurried. Man's movements have become more hesitating. They have no more the athletic and resolute strength with which former men grappled all things. They do not resemble those movements that are preserved in ancient images, those gestures of which only the first and the last were important. Between these two simple movements innumerable transitions have been interpolated, and it is manifest that it is just in these intervening moments that the life of the man of today passes by; his action and his disability for action, the seizing, the holding, the abandoning has changed. In everything there is much more experience and at the same time more ignorance; there is despondency and a continuous attack against opposition; there is grief over things lost; there is calculation, judgment, consideration and less spontaneity.

Rodin has discovered these gestures, has evolved them out of one or several figures and moulded them

into sculptural forms. He has endowed hundreds and hundreds of figures that were only a little larger than his hand with the life of all passions, the blossoming of all delights and the burden of all vices. He has created bodies that touch each other all over and cling together like animals bitten into each other, that fall into the depth of oneness like a single organism; bodies that listen like faces and lift themselves like arms; chains of bodies, garlands and tendrils and heavy clusters of bodies into which sin's sweetness rises out of the roots of pain. Leonardo only with equal power has thus joined men together in his grandiose representation of the end of the world. In his work as in this are those who throw themselves into the abyss in order to forget the great grief, and those who shatter their children's heads lest they should grow to experience the great woe.

The army of these figures became much too numerous to fit into the frame and wings of the *Gates of Hell*. Rodin made choice after choice and eliminated everything that was too solitary to subject itself to the great totality; everything that was not quite necessary was rejected. He made the figures and groups find their own places; he observed the life of the people that he had created, listened to them and left everyone to his will. Thus year after

year the world of this gate grew. Its surface to which plastic forms were attached began to live. And as the reliefs became softer and softer the excitement of the figures died away into the surface. In the frame there is from both sides an ascension, a mutual up-lifting; in the wings of the gates the predominating motion is a falling, gliding and precipitating. The wings recede somewhat and their upper edge is sep-arated from the projecting edge of the cross-frame by a large surface. Before the silent, closed room of this surface is placed the figure of *The Thinker*, the man who realizes the greatness and terror of the spectacle about him, because he *thinks* it. He sits absorbed and silent, heavy with thought: with all the strength of an acting man he thinks. His whole body has become head and all the blood in his veins has become brain. He occupies the centre of the Gate. Above him, on the top of the frame, are three male figures; they stand with heads bent together as though overlooking a great depth; each stretches out an arm and points toward the abyss which drags them ever downward. The Thinker must bear this weight within himself.

Among the groups and figures that have been mod-elled for this Gate are many of great beauty. It is im-possible to enumerate all of them as it is impossible to

describe them. Rodin himself once said that he would have to speak for one year in order to recreate one of his works in words.

These small figures which are preserved in plaster, bronze and stone, like some animal figures of the Antique, give the impression of being quite large. There is in Rodin's studio the cast of a panther, a Greek work hardly as large as a hand (the original of which is in the Cabinet of Medals in the National Library of Paris); as one stands in front of this beast and looks under its body into the room formed by the four strong, supple paws, one seems to look into the depth of an Indian stone temple. As this work grows and extends itself to the greatness of its suggestion, so the small plastic figures of Rodin convey the sense of largeness. By the play of innumerably many surfaces and by the perfect and decisive planes, he creates an effect of magnitude. The atmosphere about these figures is like that which surrounds rocks. An upward sweep of lines seems to lift up the heavens, the flight of their fall to tear down the stars.

At this time, perhaps, the *Danaïde* was created, a figure that has thrown itself from a kneeling position down into a wealth of flowing hair. It is wonderful to walk slowly about this marble, to follow the long line that curves about the richly unfolded roundness

of the back to the face that loses itself in the stone as though in a great weeping, and to the hand which like a broken flower speaks softly once more of life that lies deep under the eternal ice of the block. *Illusion*, the daughter of Icarus, is a luminous materialization of a long, helpless fall. The beautiful group that is called *L'homme et sa pensée* is the representation of a man who kneels and with the touch of his forehead upon the stone before him awakens the silent form of a woman who remains imprisoned in the stone. In this group one is impressed with the expression of the inseparableness with which the man's thought clings to his forehead; for it is his thought that lives and is always present before him, the thought which takes shape in the stone.

The work most nearly related to this in conception is the head that musingly and silently frees itself from a block. *La Pensée* is a transcendant vision of life that rises slowly out of the heavy sleep of the stone.

The Caryatid is no more the erect figure that bears lightly or unyieldingly the heaviness of the marble. A woman's form kneels crouching, as though bent by the burden, the weight of which sinks with a continuous pressure into all the figure's limbs. Upon every smallest part of this body the whole stone lies like the insistence of a will that is greater, older and more powerful,

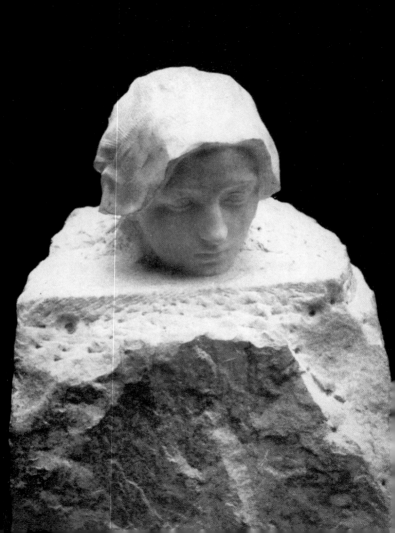

a pressure, which it is the fate of this body to continue to endure. The figure bears its burden as we bear the impossible in dreams from which we can find no escape. Even the sinking together of the failing figure expresses this pressure; and when a greater weariness forces the body down to a lying posture, it will even then still be under the pressure of this weight, bearing it without end. Such is the *Caryatid*.

One may always explain, accompany and surround Rodin's works with thoughts. For all to whom simple contemplation is too difficult and unaccustomed a road to beauty there are other roads, detours leading to meanings that are noble, great, complete. The infinite correctness of these creations, the perfect balance of all their movements, the wonderful inward justice of their proportions, their penetration into life – all that makes them beautiful – gives them the strength of being unsurpassable materializations of the ideas which the master called into being when he named them. Rodin lived near his work and, like the custodian of a museum, continuously evolved from it new meanings. One learns much from his interpretations but in the contemplation of these works, alone and undisturbed, one gathers a still fuller and richer understanding of them.

Opposite: La Pensée (Thought), 1893-95

Where the first suggestion comes from some definite subject, where an ancient tale, a passage from a poem, an historical scene or some real person is the inspiration, the subject-matter transforms itself more and more into reality during the process of the work. Translated into the language of the hands, the interpretations acquire entirely new characteristics which develop into plastic fulfilment. The drawings of Rodin prepare the way for the sculptural work by transforming and changing the suggestions. In this art, too, Rodin has cultivated his own methods of expression. The individuality of these drawings – there are many hundreds of them – presents an independent and original manifestation of his artistic personality.

There are from an earlier period watercolours with surprisingly strong effects of light and shade, such as the famous *Homme au Taureau*, which reminds one of Rembrandt. The head of the young *St Jean Baptiste* and the shrieking mask for the *Genius of War* – all these are sketches and studies which helped the artist to recognize the life of surfaces and their relationship to the atmosphere. There are drawings that are done with a direct certainty, forms complete in all their contours, drawn in with many quick strokes of the pen; there are others enclosed in the melody of a single vibrating outline. Rodin, acceding to the wish of a collector, has

illustrated with his drawings one copy of the *Fleurs du Mal*. To speak of expressing a fine understanding of Baudelaire's verses conveys no meaning; more is conveyed if it is recalled that these poems in their fullness do not admit of supplement. Yet in spite of this one feels an enchantment where Rodin's lines interpret this work, such is the measure of the overpowering beauty of these drawings. The pen and ink drawing that is placed opposite the poem *La Mort des Pauvres* exceeds these great verses with so simple and ever-growing a breadth of meaning that the sweep of its lines seems to include the universal. This quality of enhancement is also found in the dry-point etchings, in which the course of infinitely tender lines appears to flow with an absolute accuracy of movement over the underlying essence of form, like the outer markings of some beautiful crystalline thing.

The strange documents of the momentary and of the unnoticeably passing originated at this time. Rodin assumed that, if caught quickly, the simple movements of the model when he believes himself unobserved contain the strength of an expression which is not surmised, because one is not wont to follow it with intense and constant attention. By not permitting his eyes to leave the model for an instant, and by allowing his quick and trained hand free play over the drawing

paper, Rodin seized an enormous number of never before observed and hitherto unrecorded gestures of which the radiating force of expression was immense. Conjoining movements that had been overlooked and unrecognized as a whole represented and contained all the directness, force and warmth of animal life. A brush full of ochre outlined the contours with quickly changing accentuation, modelled the enclosed surface with such incredible force that the drawing appears like a figure in terracotta. And again a new depth was discovered full of unsurmised life; a depth over which echoing steps had passed and which gave its waters only to him whose hands possessed the magic wand that disclosed its secret.

In portraiture the pictorial expression of the theme belonged to the preparation from which Rodin proceeded slowly to the completion of the work. For erroneous as it is to see in Rodin's plastic art a kind of Impressionism, it is the multitude of precisely and boldly seized impressions that is always the great treasure from which he ultimately chooses the important and necessary, in order to comprehend his work in its perfect synthesis. As he proceeds from the bodies to the faces it must seem to him as though he stepped from a windswept distance into a room in which many men are gathered. Here everything is

crowded and dim and the mood of an interior pre-
dominates under the arches of the brow and in the
shadows of the mouth. Over the bodies there is al-
ways change, an ebb and flood like the dashing of
waves. The faces possess an atmosphere like that of
rooms in which many things have happened, joyous
and tragic incidents, experiences deadening or full of
expectation. No event has entirely passed, none has
taken the place of the other, one has been placed be-
side the other and has remained there and has with-
ered like a flower in a glass. But he who comes from
the open out of the great wind brings distance into
the room.

The mask of *The Man with the Broken Nose* was the
first portrait that Rodin modelled. In this work his
individual manner of portraying a face is entirely
formed. One feels his admitted devotion to reality, his
reverence for every line that fate has drawn, his con-
fidence in life that creates even where it disfigures. In
a kind of blind faith he sculpted *L'Homme au nez cassé*
without asking who the man was who lived again in
his hands. He made this mask as God created the first
man, without intention of presenting anything save
Life itself – immeasurable Life. But he returned to the
faces of men with an ever-growing, richer and greater
knowledge. He could not look upon their features

without thinking of the days that had left their impress upon them, without dwelling upon the army of thoughts that worked incessantly upon a face, as though it could never be finished. From a silent and conscientious observation of life, the mature man, at first groping and experimenting, became more and more sure and audacious in his understanding and interpretation of the script with which the faces were covered. He did not give rein to his imagination, he did not invent, he did not neglect for a moment the hard struggle with his tools. It would have been easy to surmount, as if with wings, these difficulties. He walked side by side with his work over the far and distant stretches that had to be covered, like the ploughman behind his plough. While he traced his furrows, he meditated over his land, the depth of it, the sky above it, the flights of the winds and the fall of the rains; considered all that existed and passed by and returned and ceased not to be. He recognized in all this the eternal, and becoming less and less perplexed by the many things, he perceived the one great thing for which grief was good, and heaviness promised maternity, and pain became beautiful.

The interpretation of this perception began with the portraits, and from that time penetrated ever deeper into his work. It is the last step, the last cycle

in his development. Rodin began slowly and with infinite precaution entered upon this new road. He advanced from surface to surface following Nature's laws. Nature herself pointed out to him, as it were, the places in which he saw more than was visible. He evolved one great simplification out of many confusions as Christ brought unity into the confusion of a guilty people by the revelation of a sublime parable. He fulfilled an intention of nature, completed something that was helpless in its growth. He disclosed the coherences as a clear evening following a misty day unveils the mountains which rise in great waves out of the far distance.

Full of the vital abundance of his knowledge, he penetrated into the faces of those that lived about him, like a prophet of the future. This intuitive quality gives to his portraits the clear accuracy and at the same time the prophetic greatness which rises to such indescribable perfection in the figures of Victor Hugo and Balzac. To create an image meant to Rodin to seek eternity in a countenance, that part of eternity with which the face was allied in the great course of things eternal. Each face that he has modelled he has lifted out of the bondage of the present into the freedom of the future, as one holds a thing up toward the light of the sky in order to understand its purer and

simpler forms. Rodin's conception of Art was not to beautify or to give a characteristic expression but to separate the lasting from the transitory, to sit in judgment, to be just.

Beside the etchings, his portrait work embraces a great number of finished and masterly drawings. There are busts in plaster, in bronze, in marble and in sandstone, heads and masks in terracotta. Portraits of women occur again and again through all the periods of his work. The famous bust of the Luxembourg is one of the earliest. This bust is full of individual life, of a certain beautiful, womanly charm, but it is surpassed in simplicity and concentration by many later works. It is, perhaps, the only bust which possesses a beauty not absolutely characteristic of Rodin's work. This portrait survives partly because of a certain graciousness which has been hereditary for centuries in French plastic art. It shines somewhat with the elegance of the inferior sculptures of French tradition; it is not quite free from that gallant conception of the 'belle femme' beyond which the serious and the deeply penetrating work of Rodin grew so quickly. One should remember that he had to overcome the ancestral conception, had to suppress an inborn capacity for this flowing grace in order to begin his work quite simply. He must not

Opposite: Mme Rodin, 1890

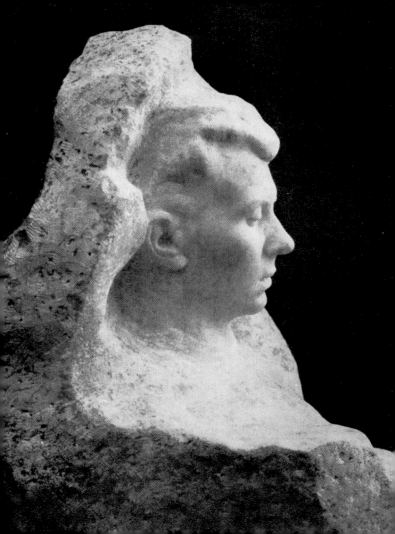

cease to be a Frenchman; the master builders of the cathedrals were also Frenchmen.

His later sculptures of women have a different beauty, more deeply founded and less traditional. Rodin has, for the most part, executed portraits of foreign women, especially American women. There are among these busts some of wonderful craftsmanship, marbles that are like pure and perfect antique cameos, faces whose smiles play softly over the features like veils that seem to rise and fall with every breath; strangely half-closed lips and eyes which seem to look dreamily into the bright effulgence of an everlasting moonlit night. To Rodin the face of a woman seems to be a part of her beautiful body. He conceives the eyes of the face to be eyes of the body, and the mouth the mouth of the body. When he creates both face and body as a whole, the face radiates so vital an expression of life that these portraits of women seem prophetic.

The portraits of men are different. The essence of a man can be more easily imagined to be concentrated within the limits of his face; there are moments of calm and of inward excitement in which all life seems to have entered into his face. Rodin chooses or rather creates these moments when he models a man's portrait. He searches far back for individuality or

character, does not yield to the first impression, nor to the second, nor to any of those following. He observes and makes notes; he records almost unnoticeable moments, turnings and semi-turnings of many profiles from many perspectives. He surprises his model in relaxation and in effort, in his habitual as well as in his impulsive expressions; he catches expressions which are but suggested. He comprehends transitions in all their phases, knows whence the smile comes and why it fades. The face of man is to him like a scene in a drama in which he himself takes part. Nothing that occurs is indifferent to him or escapes him. He does not urge the model to tell him anything, he does not wish to know aught save that which he sees. He sees everything.

Thus a long time passes during the creation of each work. The conception evolves partly through drawings, seized with a few strokes of the pen or a few lines of the brush, partly from memory. For Rodin has trained his memory to be a means of assistance as dependable as it is comprehensive. During the hours in which the model poses he perceives much more than he can execute. Often after the model has left him the real work begins to take form from out the fullness of his memory. The impressions do not change within it but accustom themselves to their dwelling-place and

rise from it into his hands as though they were the natural gestures of these hands.

This manner of work leads to an intense comprehension of hundreds and hundreds of moments of life. And such is the impression produced by these busts. The many wide contrasts and the unexpected changes which comprise man and man's continuous development here join together with an inner strength. All the heights and depths of being, all the climates of temperament of these men are concentrated and unfold themselves on the hemispheres of their heads. There is the bust of Dalou in whom a nervous fatigue vibrates side by side with a tenacious energy. There is Henri Rochefort's adventurous mask, and there is Octave Mirbeau in whom behind a man of action dawns a poet's dream and longing, and Puvis de Chavannes, and Victor Hugo whom Rodin knows so well; and there is above all the indescribably beautiful bronze portrait bust of the painter Jean-Paul Laurens which is, perhaps, the most beautiful thing in the Luxembourg Museum. This bust is penetrated by such deep feeling, there is such tender modelling of the surface, it is so fine in carriage, so intense in expression, so moved and so awake that

Opposite: Jean-Paul Laurens, 1881

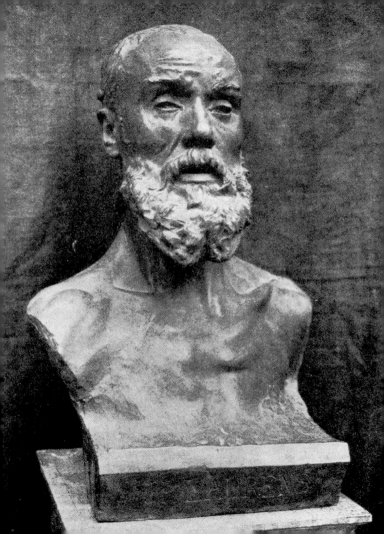

it seems as if Nature had taken this work out of the sculptor's hands to claim it as one of her most precious possessions. The gleam and sparkle of the metal that breaks like fire through the smoke-black patina coating adds much to make perfect the unique beauty of this work.

There is also a bust of Bastien-Lepage, beautiful and melancholy with the expression of the suffering of the man whose realization is a continuous departure from his conception. This bust was executed for Damvillers, the little home village of the painter, and was placed there in the churchyard as a monument.

In their breadth of conception these busts of Rodin's have something of the monumental in them. To this quality is added a greater simplification of the surfaces, and a still more severe choice of the necessary with a view to perspective and placement. The monuments which Rodin has created approach more and more these requirements. He began with the monument of Claude Gelée for Nancy, and there is a steep ascent from this first interesting production to the grandiose triumph of Balzac.

Several of the monuments by Rodin were sent to America. The most mature of them was destroyed during the disturbances in Chile before it reached its destination. This was the equestrian statue of General

Lynch. Like the lost masterpiece of Leonardo, which it resembled perhaps in the force of expression and in the wonderfully vital unity of man and horse, this statue was not to be preserved. A small copy in plaster in Rodin's museum at Meudon shows that it was the plastic portrait of a lean man who rises commandingly in his saddle, not in the brutal, tyrannical manner of a condottiere but with the nervous excitement of one who exercises the power of command only in office but who is not ordinarily wont to use this authority. The forward-pointing hand of the general rises out of the mass of the monument, out of man and animal.

This gesture of command gives to the statue of Victor Hugo its memorable power and majesty. The gesture of the aged man's strong, live hand raised commandingly toward the ocean does not come from the poet alone but descends from the summit of the whole group as though from a mountain on which it had prayed before it spoke. Victor Hugo is here the exile, the solitary of Guernsey. The muses that surround him are like thoughts of his solitude become visible. Rodin has conveyed this impression through the intensification and concentration of the figures about the poet. By converging the points of contact Rodin has succeeded in creating the impression that

these wonderfully vibrant figures are parts of the sitting man. They move about him like great gestures made sometime during his life, gestures that were so beautiful and young that a goddess granted them the grace not to perish but to endure forever in the forms of beautiful women.

Rodin made sketches and studies of the figure of the poet. At the time of the receptions in the Hotel Lusignan he observed from a window and made notes of hundreds and hundreds of movements and of the changing expressions of the animated face of the old man. These preparations resulted in the several portraits of Hugo which Rodin modelled. The monument itself embodied a still-deeper interpretation. All these single impressions he gathered together, and as Homer created a perfect poem out of many rhapsodies, so he created from all the pictures in his memory this one portrait. And to this last picture he gave the greatness of the legendary. Myth-like it might return to a fantastically towering rock in the sea in whose strange forms far-removed peoples see life asleep.

The most supreme instance of Rodin's power of exalting a past event to the height of the imperishable, whenever historical subjects or forms demand to live again in his art, is found perhaps in *The Citizens of Calais*. The suggestion for this group was taken from a

few passages in the chronicles of Froissart that tell the story of the City of Calais at the time it was besieged by the English king, Edward the Third. The king, not willing to withdraw from the city, then on the verge of starvation, ultimately consents to release it if six of its noble citizens deliver themselves into his hands 'that he may do with them according to his will'. He demands that they leave the city bareheaded, clad only in their shirts, with a rope about their necks and the keys of the city and of the citadel in their hands. The chronicler describes the scene in the city. He relates how the burgomaster, Messire Jean de Vienne, orders the bells to be rang and the citizens to assemble in the market-place. They hear the final message and wait in expectation and in silence. Then heroes rise among them, the chosen ones, who feel the call to die. The wailing and weeping of the multitude rises from the words of the chronicler, who seems to be touched for the moment and to write with a trembling pen. But he composes himself once more and mentions four of the heroes by name; two of the names he forgets. He says that one man was the wealthiest citizen of the city and that another possessed authority and wealth

Overleaf: Les Bourgeois de Calais (The Citizens of Calais, also known as The Burghers of Calais), 1884-86

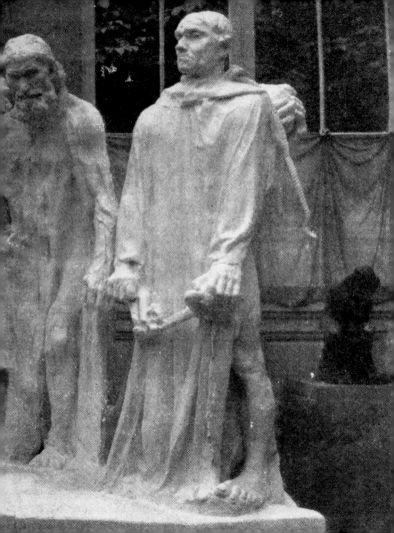

and 'had two beautiful maidens for daughters'; of the third he only knows that he was rich in possessions and heritage, and of the fourth that he was the brother of the third. He reports that they removed all their clothing save their shirts, that they tied ropes about their necks and thus departed with the keys of the city and of the citadel. He tells how they came to the king's camp and of how harshly the king received them and how the executioner stood beside them when the king, at the request of the queen, gave them back their lives. 'He listened to his wife,' says Froissart, 'because she was very pregnant.' The chronicle does not continue further.

For Rodin this was sufficient material. He felt immediately that there was a moment in this story when something portentous took place, something independent of time and place, something simple, something great. He concentrated all his attention upon the moment of the departure. He saw how the men started on their way, he felt how through each one of them pulsated once more his entire past life, he realized how each one stood there prepared to give that life for the sake of the old city. Six men rose before him, of whom no two were alike, only two brothers were among them between whom there was, possibly, a certain similarity. But each of them had resolved

to live his last hour in his own way, to celebrate it with his soul and to suffer for it with his body, which clung to life. Rodin then no longer saw the forms of these men. Gestures rose before him, gestures of renunciation, of farewell, of resignation. Gestures over gestures. He gathered them together and gave them form. They thronged about him out of the fullness of his knowledge, a hundred heroes rose in his memory and demanded to be sacrificed. And he concentrated this hundred into six. He modelled them each by himself in heroic size to represent the greatness of their resolution, modelled them nude in the appeal of their shivering bodies.

He created the old man with loose-jointed, hanging arms and heavy, dragging step, and gave him the worn-out walk of old men and an expression of weariness that flows over his face into the beard.

He created the man that carries the key, the man who would have lived for many years to come, but whose life is condensed into this sudden last hour which he can hardly bear. His lips are tightly pressed together, his hands bite into the key. There is fire in his strength and it burns in his defiant bearing.

He created the man who holds his bent head with both hands to compose himself, to be once more alone.

He created the two brothers, one of whom looks

backward while the other bends his head with a movement of resolution and submission as though he offered it to the executioner.

He created the man with the vague gesture whom Gustave Geffroy has called *Le Passant*. The man moves forward, but he turns back once more, not to the city, not to those who are weeping, and not to those who go with him: he turns back to himself. His right arm is raised, bent, vacillating. His hands open in the air as though to let something go, as one gives freedom to a bird. This gesture is symbolic of a departure from all uncertainty, from a happiness that has not yet been, from a grief that will now wait in vain, from men who live somewhere and whom he might have met sometime, from all possibilities of tomorrow and the day after tomorrow; and from Death which he had thought far distant, that he had imagined would come mildly and softly and at the end of a long, long time.

This figure, if placed by itself in a dim, old garden, would be a monument for all who have died young.

Thus Rodin has made each of these men live again the last concentrated moment of life. Each figure is majestic in its simple greatness. They bring to mind Donatello and, perhaps, Claus Sluter and his prophets in the Chartreuse of Dijon.

It seems at first as though Rodin had done nothing more than gather them together. He has given them the same attire, the shirt and the rope, and has placed them together in two rows: the three that are in the first row are about to start forward, the other three turn to the right and follow behind. The place that was decided upon for the erection of the monument was the market-place of Calais, the same spot from which the tragic procession had formerly started. There the silent group was to stand, raised by a low step above the common life of the market-place as though the fearful departure was always pending.

The City of Calais refused to accept a low pedestal because it was contrary to custom. Rodin then suggested that a square tower, two storeys high and with simply-cut walls, be built near the ocean and there the six citizens should be placed, surrounded by the solitude of the wind and the sky. This plan, as might have been expected, was declined, although it was in harmony with the character of the work. If the trial had been made, there would have been an incomparable opportunity for observing the unity of the group, which, although it consisted of single figures, held closely together as a whole. The figures do not touch one another, but stand side by side like the last trees of a hewn-down forest united only by the

surrounding atmosphere. From every point of view the gestures stand out clear and great from the dashing waves of the contours; they rise and fall back into the mass of stone like flags that are furled. The entire impression of this group is precise and clear. Like all of Rodin's compositions, this one, too, appears to be a pulsating world enclosed within its own boundaries. Beside the points of actual contact there is a kind of contact produced by the surrounding atmosphere which diminishes, influences and changes the character of the group. Contact may exist between objects far distant from one another, like the conflux of forms such as one sees sometimes in masses of clouds, where the interjacent air is no separating abyss but rather a transition, a softly-graduated conjunction.

To Rodin the participation of the atmosphere in the composition has always been of greatest importance. He has adapted all his figures, surface after surface, to their particular space and environment; this gives them the greatness and independence, the marvellous completeness and life which distinguishes them from all other works. When interpreting nature he found, as he intensified an expression, that, at the same time, he enhanced the relationship of the atmosphere to his work to such a degree that the surrounding air seemed to give more life, more passion,

as it were, to the embraced surfaces. A similar effect may be observed in some of the animals on the cathedrals to which the air relates itself in strange fashion; it seems to become calm or storm according to whether it sweeps over emphasized or level surfaces. When Rodin concentrates the surfaces of his works into culminating points, when he uplifts to greater height the exalted or gives more depth to a cavity, he creates an effect like that which atmosphere produces on monuments that have been exposed to it for centuries. The atmosphere has traced deeper lines upon these monuments, has shadowed them with veils of dust, has seasoned them with rain and frost, with sun and storm, and has thus endowed them with endurance so that they may remain imperishable through many slowly-passing dusks and dawns.

The effect of atmosphere, which is the monumental principle of Rodin's art, is wonderfully achieved in *The Citizens of Calais*. These sculptural forms seen from a distance are not only surrounded by the immediate atmosphere but by the whole sky; they catch on their surfaces as with a mirror its moving distances so that a great gesture seems to live and to force space to participate in its movement.

This impression is conveyed also by the figure of the slender youth who kneels with outstretched, imploring

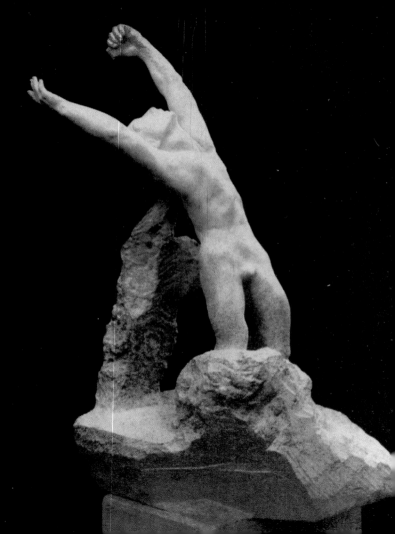

arms. Rodin has called this figure *The Prodigal Son*, but it has recently received the name – from whom or in what manner no one knows – of *Prière*. The gesture of this figure raises it even beyond this name. This is no son kneeling before his father. A God is necessary to him who thus implores and in him are all who need this God. This prayer in stone reaches out to such distance that the figure seems to be withdrawn into a great isolation.

Such, too, is the *Balzac* to whom Rodin has given a greatness which, perhaps, overtowers the figure of the writer. Rodin has seized upon the essence of Balzac's being, has not confined himself to the limitations of his personality but has gone beyond into his most extreme and distant possibilities. These mighty contours might have been formed in the tombstones of bygone nations.

For years Rodin was entirely absorbed in this figure. He visited Balzac's home, he went to the landscapes of the Touraine that rise continually in Balzac's books; he read his letters, he studied the portraits of Balzac and he read his works again and again. On all the intricate and intertwining roads of these works he was met by the people of Balzac, whole families and generations, a world that still seemed to receive

Opposite: L'enfant prodigue (The Prodigal Son), before 1889

life from its creator. Rodin saw that all these thousands of people, no matter what their occupation or their life, contained him who had created them. As one may perceive the character and the mood of a play through the faces of an audience, so he sought in all these faces him who still lived in them. He believed like Balzac in the reality of his world and he became for a time a part of it. He lived as though Balzac had created him also, and he dwelt unnoticed among the multitude of his people. Thus he gathered his impressions. The actual world appeared at this time vague and unimportant. The daguerreotypes of Balzac offered only general suggestions and nothing new. The face which they represented was the one he had known from boyhood days. The one that had been in the possession of Stéphane Mallarmé, which showed Balzac without coat and suspenders, was the only one which was more characteristic. Reminiscences of contemporaries helped him; the words of Théophile Gautier, the notes of the Goncourts, and the beautiful essay by Lamartine. Beside these pen portraits there was only the bust by David in the Comédie Française and a small picture by Louis Boulanger. Completely filled with the spirit of Balzac, Rodin, with the aid of these auxiliaries, began to

Opposite: Balzac, 1897

model the figure of the writer. He used living models of similar proportions and completed seven perfectly executed portraits in different positions. The models were thick-set, medium-sized men with heavy limbs and short arms. After these studies he created a *Balzac* much like the one in Nadar's daguerreotype. But he felt this was not final.

He returned to the description of Lamartine, to the lines: 'He had the face of an element,' and 'he possessed so much soul that his heavy body seemed not to exist.' Rodin felt that a great part of his task was suggested in these sentences. He approached nearer its solution by clothing the seven figures with monk's cowls, the kind of garment that Balzac was wont to wear while at work. He created a *Balzac* with a hood, a garb much too intimate, the figure much too retired into the stillness of its disguise.

Rodin slowly developed form after form. At last he saw Balzac. He saw a mighty, striding figure that lost all its heaviness in the fall of its ample cloak. The hair bristled from the nape of the powerful neck. And backward against the thick locks leaned the face of a visionary in the intoxication of his dream, a face flashing with creative force: the face of an element. This was Balzac in the fullness of his productivity, the founder of generations, the waster of fates. This was

the man whose eyes were those of a seer, whose visions would have filled the world had it been empty. This was the Balzac that Creation itself had formed to manifest itself and who was Creation's boastfulness, vanity, ecstasy and intoxication. The thrownback head crowned the summit of this figure as lightly as a ball is upheld by the spray of a fountain. There was no sense of weight, but a magnificent vitality in the free, strong head.

Rodin had seen in a moment of large comprehension and tragic exaggeration his Balzac and thus he created him. The vision did not fade; it only changed.

The comprehensiveness which gave breadth to Rodin's monumental works gave to the others also a new beauty; it gave them a peculiar nearness. There are among the more recent works small groups that are striking because of their concentration and the wonderful treatment of the marble. The stones preserve, even in the midst of the day, that mysterious shimmer which white things exhale in the twilight. This radiance is not the result of the vibrant quality of the points of contact alone, but is due in part to the flat ribands of stone that lie between the figures like small bridges which connect one form with the other over the deepest clefts in the modeling. These riband fillings are not incidental but are placed there to prevent

too sharp an outline. They preserve in the forms that otherwise would appear too clear-cut an effect of roundness; they gather the light like vases that gently and continuously overflow. When Rodin seeks to condense the atmosphere about the surfaces of his works, the stone appears almost to dissolve in the air; the marble is the compact, fruitful kernel, and its last, softest contour the vibrating air. The light touching the marble loses its will, it does not penetrate into the stone, but nestles close, lingers, dwells in the stone.

This closing up of unessential clefts is an approach to the relief. Rodin planned a great work in relief in which there were to be effects of light such as he achieved in the smaller groups. He constructed a column about which a broad riband of relief winds upward. This encircling riband conceals a staircase which ascends under arched vaultings. The figures in this ascending relief are modelled and placed so as to receive an effect of life and vibrance from the atmosphere and lighting.

A plastic art will sometime rise which will disclose the secret of twilight as it is related to those sculptures that stand in the vestibules of old cathedrals.

This *Monument of Work* represents a history of work which develops upon these slowly rising reliefs. The long line begins in a lower chamber or crypt with the

figures of those who have grown old in mines. The procession traces its steps through all the phases of work, from those who work in the roar and red glow of furnaces to those who work in silence in the light of a great idea: from the hammers to the brains. Two figures guard the entrance, *Day* and *Night*, and upon the summit of this tower stand two winged forms to symbolize the Blessings descending from the luminous heights. Rodin did not conceive work as a monumental figure or a great gesture, for work is something near; it takes place in the shops, in the rooms, in the heads, in the dark.

He knows, for he, too, worked; he worked incessantly; his life passed like a single working day.

Rodin had several studios, some that are well-known in which visitors and letters found him. There were others in out-of-the-way, secluded places of which no one knew. These rooms were like cells, bare, poor and grey with dust, but their poverty was like the great, grey poverty of God out of which trees bud in March. Something of the Spring was in each of these rooms, a silent promise and a deep seriousness.

In one of these studios *The Tower of Work* has risen. Now that it is accomplished, it is time to speak of its significance. Sometime after this monument has been

erected it will be recognized that Rodin willed nothing that was beyond his art. The body of work here manifests itself as did formerly the body of love:– it is a new revelation of life. This creator lived so completely in his conceptions, so entirely in the depths of his work, that inspiration or revelation came to him only through the medium of his art. New life in the ultimate sense meant to him new surfaces, new gestures. Thus to him the meaning of life became simple; he could err no more.

With his own development Rodin has given an impetus to all the arts in this confused age. Sometime it will be realized what has made this great artist so supreme. He was a worker whose only desire was to penetrate with all his forces into the humble and difficult significance of his tools. Therein lay a certain renunciation of Life, but in just this renunciation lay his triumph, for Life entered into his work.

Opposite: La Tour du Travail (Monument – or Tower – of Work), 1898-99

© 2006, 2018 Pallas Athene

Published in the United States of America by the J. Paul Getty Museum, Los Angeles
Getty Publications
1200 Getty Center Drive, Suite 500
Los Angeles, California 90049-1682
www.getty.edu/publications

Distributed in the United States and Canada by the University of Chicago Press

Printed in China

ISBN 978-1-60606-561-7
Library of Congress Control Number: 2017946359

Published in the United Kingdom by Pallas Athene (Publishers) Limited
Studio 11A, Archway Studios, 25–27 Bickerton Road, London N19 5JT

Series editor: Alexander Fyjis-Walker
Editorial assistant: Anaïs Métais

Front cover: Edward Steichen, *Portrait of Auguste Rodin*, negative 1902, print about 1963. Gelatin silver print, 24.8 x 18.3 cm (9¾ x 7³⁄₁₆ in.). J. Paul Getty Museum, 84.XM.157.1. © 2018 The Estate of Edward Steichen / Artists Rights Society (ARS), New York

Note on the Text and Illustrations
Rilke's text *Rodin* was written in 1903. This translation was prepared by Jessie Lemont and Hans Trausil and first published in New York in 1919; it was republished in England in 1946. Apart from the *Caryatid* on p. 1, which is reproduced from the English edition, all the illustrations are reproduced from the first German edition, including the photograph of Rodin in his garden on p. 2, and the initial R on p. 15.